T0197679

ALL IN A SHEEP'S WORLD

ALL IN A SHEEP'S WORLD

MARY HOOD

authorHOUSE®

AuthorHouse™
1663 Liberty Drive
Bloomington, IN 47403
www.authorhouse.com
Phone: 1-800-839-8640

© *2012 Mary Hood. All rights reserved.*

No part of this book may be reproduced, stored in a retrieval system, or transmitted by any means without the written permission of the author.

Published by AuthorHouse 04/16/2012

ISBN: 978-1-4685-8756-2 (sc)
ISBN: 978-1-4685-8755-5 (e)

Library of Congress Control Number: 2012904671

Any people depicted in stock imagery provided by Thinkstock are models, and such images are being used for illustrative purposes only.
Certain stock imagery © Thinkstock.

This book is printed on acid-free paper.

Because of the dynamic nature of the Internet, any web addresses or links contained in this book may have changed since publication and may no longer be valid. The views expressed in this work are solely those of the author and do not necessarily reflect the views of the publisher, and the publisher hereby disclaims any responsibility for them.

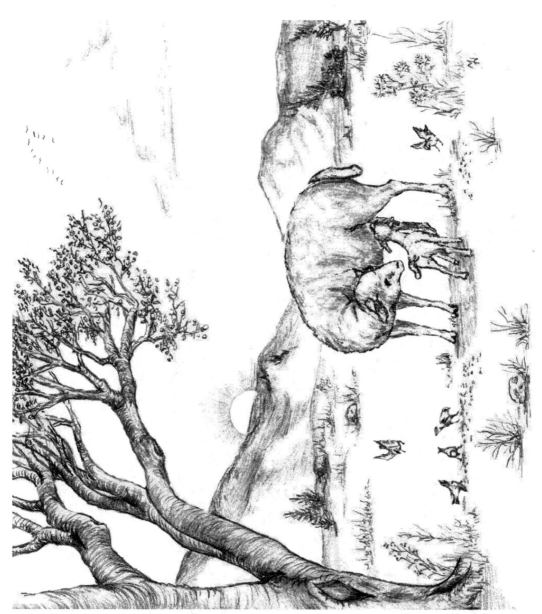

A Beautiful Spring Day

A Cold Winter Moon

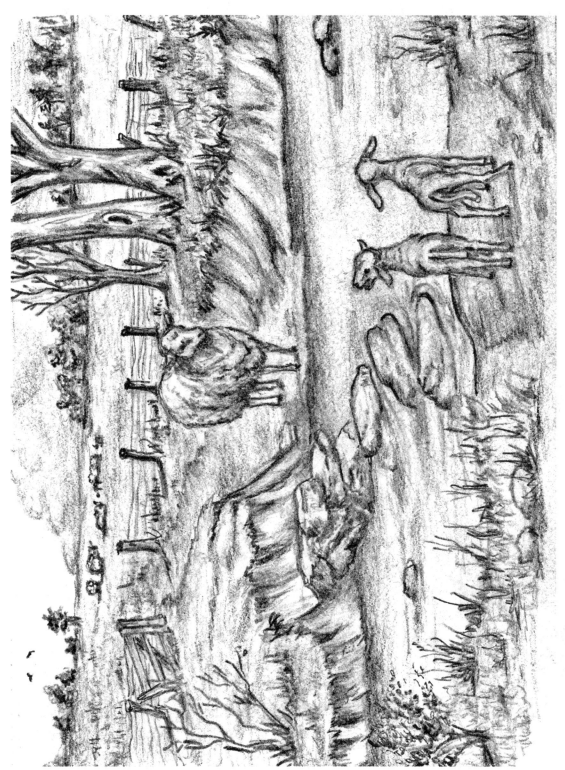

The First Crossing

A Few Extra Bites

A Fresh Morning Snow

A Friendly Surprise

A Little Extra Love

An Ominous Interruption

Are You Asleep?

A Mother's Love

At The Salt Lick

A New Arrival

A Fall Afternoon

Barnyard Games

Bucket Head

Away To The Field

Cool, Clear Water

A Shade Is A Shade

Another Baby To Care For

Curiosity

All is Well

Do We Eat It?

Best Buddies

Everybody Loves A Baby

Are You Lost Too?

A New Baby Lamb? Not This Time

Faithful Companion

Barnyard Friends

A Restful Day

Everyone Needs A Friend

Are You My Mommy?

Grazing The Rocks

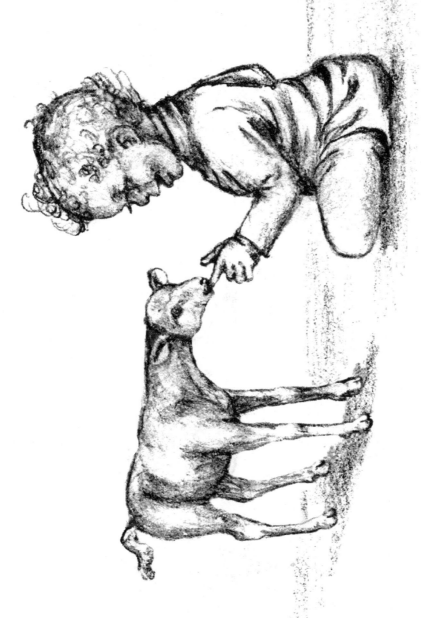

Fascination

Found At Last!

Hang On Sonny!

His First Daylight

Happy Birthday, Baby

Home Sweet Home

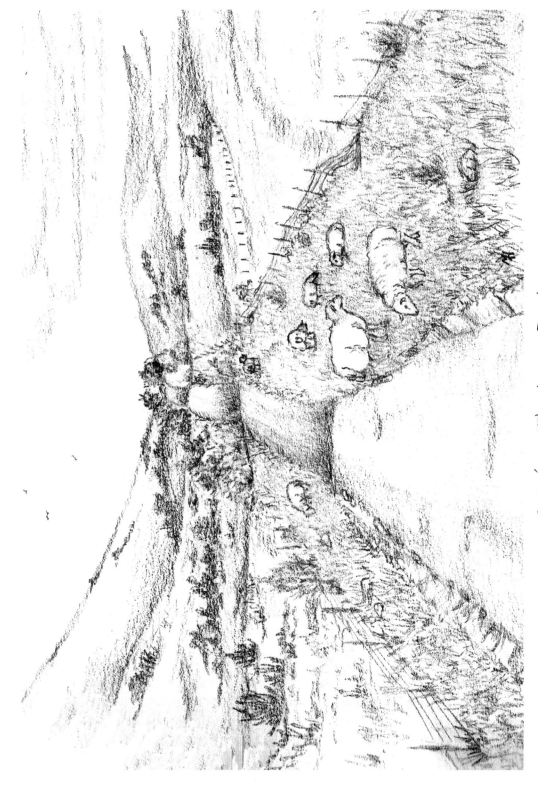

Grazing The Long Pasture

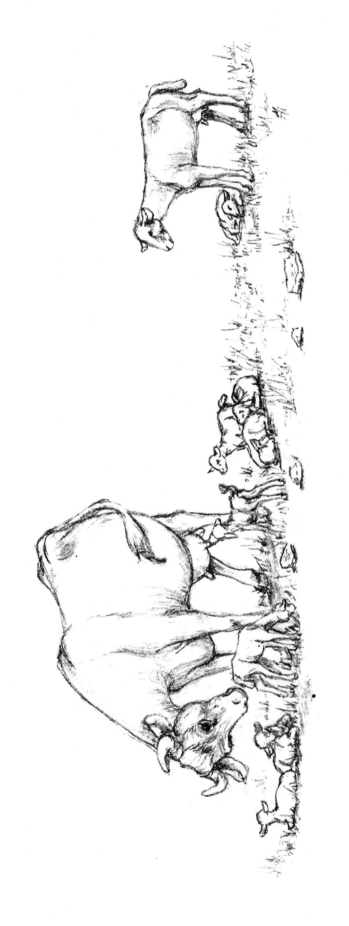

How'd She Do That?

I Fold Up Someway

I Found It First !

In The Grove

Keep 'em Back Boy!

Mischief Makers

'Neath The Old Shade Tree

Is Everybody Here?

Oh No You Don't !

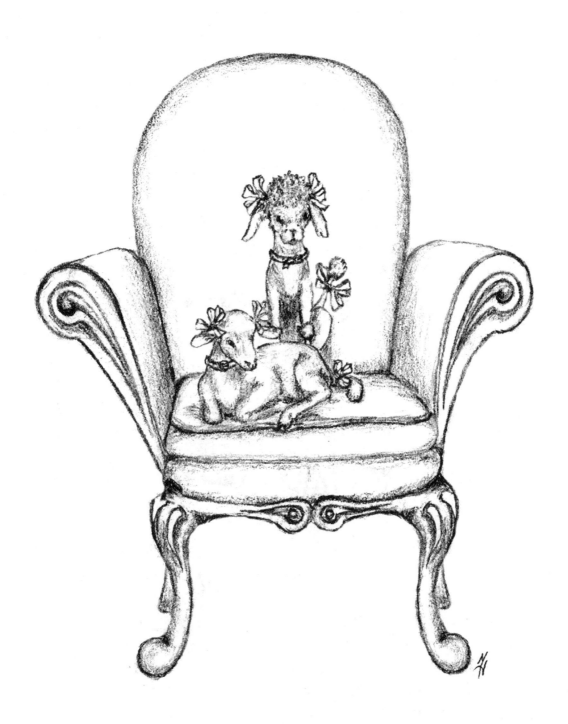

Pet Lamb ? What Pet Lamb ?

Is It Yours ?

Playmates

It's Feeding Time

Junkyard Mower

Into The Field They Go

Peaceful Rest

Putting The Buck In His Place

Safe In Mother's Arms

It's Not Mama, But It's Milk

Just In Time For The Rain

On The Road Again

Keeping Warm

Open! Open!

Kitty Curiosity

Sheltered From The Wind

Sneaking A Bite

Something Is About To Happen

Safe In The Fold

Settling Down

She's Mine!

She's Mine

I Just Want To See

Lazy Summer Days

Mama Makes A Good Bed

Naptime

Oh, No!

Peace And Solitude

Shearing Time

Signs of Spring

Sleep, Baby, Sleep

Little Lamb Rodeo

Surprise !

Look, But Don't Touch

The Guardian Angel

The Oasis

The Start of A Herd

There's Enough For All

Three Cheviots

Tickle, Tickle

Time To Stand Up

Three Generations

Two New Friends

uh, oh, oh, oh, oh

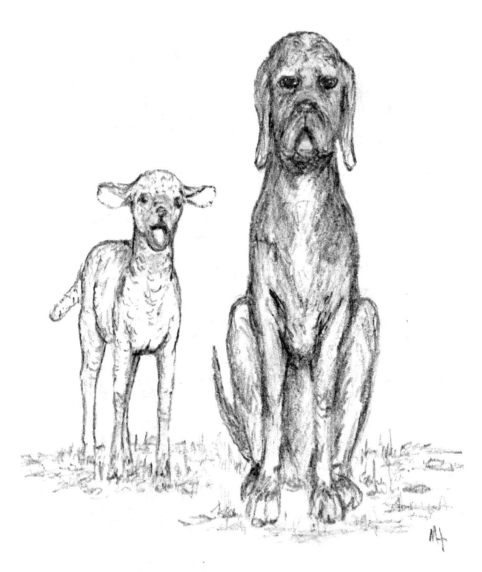

We Belong Together

We Just Got Bumped

Unexplored Territory

Waiting 'Till Mama Comes

Weaning Time

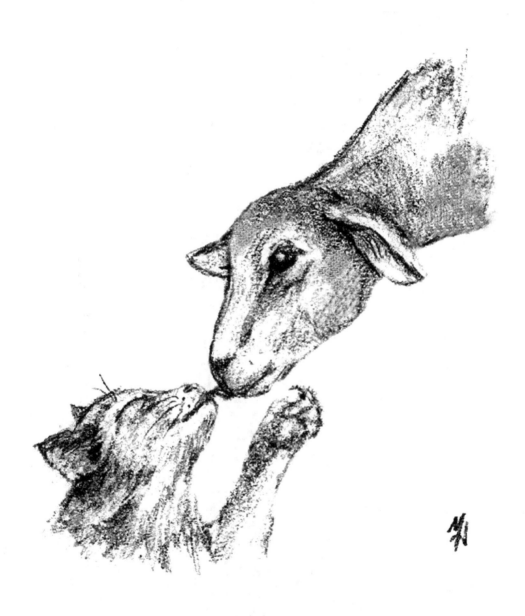

You Taste Like Milk

Winter Sunshine Feels So Good

Where's Your Mama ?

We'll Rest Here Awhile

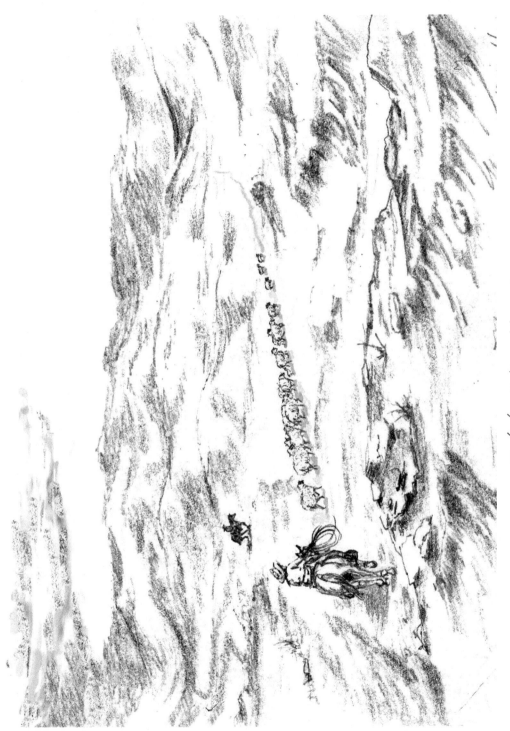

Driving 'em Home

The End

Old Grudge

One cold drizzely day I drove into town
and stopped at the little cafe.
The coffee was hot and the gossip was too.
I guess a lot happened that day.

I'd heard all the gossip and took my last supp
when a long-time acquaintance drove up in his truck.
He looked straight at me as he came in
and gave me a "Howdy" with a strange little grin.

"Know anybody that's in need of a dog?"
he said with a blustery voice.
"He's the last of the litter" he said with a nod,
"but I know he'd still be my first choice."

"I brought him with me as I came in today,
in hopes that I might possibly give him away.
He's really a young dog, still just a pup.
If you'd like to see him, he's out in my truck."

Well he looked like a rat, all shivery and wet,
no full border collie I'd be willin' to bet.
His eyes were too close and his nose was too long.
His hair was all black and his tail was all gone.

My friend said "This dog sure ain't much for lookin',
but if you need a sheep dog, he'll make you a good'n'.
There was somethin' in my coffee! There just had to
be, 'cause whenever I left; I took him with me.

Now, I had a few sheep as wild as deer.
They hadn't been penned in over a year.
My new dog and I went out to the lot
cause I was anxious to see what kind of dog I had
got.

The sheep were all grazin' on top of the hill
and he took off a runnin' like a good sheepdog will.
Then he ran and he chased a rabbit he'd found.
I said "He ain't no Border collie. I got me a hound.

He continued to hunt as the weeks went by.
In one big coon fight he lost one ear and one eye.
After one close call, he lost more of his tail,
but he couldn't be beat in pickin' up trails.

I figured my friend must have been holdin' a grudge
to give me such a sorry old pup.
I determined to train him in spite of my friend,
But I don't know how to teach that old mutt.

My trainin' wasn't workin', as hard as I tried, but I
wasn't about to give up.
I worked with him each day in the usual way,
but he was still just too much of a pup.

In order to train him, I had to name him
and not be too quick to judge.
So after much waitin' and much agravation,
I settled on the name of Old Grudge.

As months went by, he continued to hunt;
and I tried to teach him to herd.
But still every day he ran and he played,
apparently not hearing a word.

He jumped and he played, stuck his nose in a stump,
and jumped back with a yowel when he pulled out a
skunk.
She sprayed him real good when she turned around;
so he wallowed and snorted, and rolled on the
ground.

By now I'm convinced I got me a hound.
In all of this time not one sheep had he found.
One day we went walkin' to check sheep on the hill,
and had it not been for Grudge, they just might be
there still.

I started walkin' homeward not to bother the herd;
and when I looked back at him, he was chasin' a bird.
Barkin' and runnin' and takin' big leaps
he was chasin' that bird straight into the sheep.

'Oh no", I cried as he scattered the herd like a big
bunch of quail;
as he ran and he barked and wiggled that tail.

The sheep all stampeded right past the barn to open
pastures as they ran away.
I whistled and hollered "Way round you old hound",
but I knew that no sheep would be penned on this
day.

I'd finally decided I'd better give up.
I had no more use for that worthless old pup.
That night a friend called that he had a good deal.
The price for sheep was good, to good to be real.

It's not very often things come together like that.
It was a great offer and my sheep were all fat.
Out in the boonies and having no help,
I'd have to gather the sheep by myself.

As fate would have it, the sheep were so far,
They couldn't be gathered by truck or by car.
So I took off on foot to go round the sheep,
while Grudge was just lying on the porch sound
asleep.

A few miles out he came up the trail
a runnin' in circles and wigglin' his tail.
We went over a hill and the sheep were in sight
when Old Grudge found a coon and started a fight.

You ne'er heard such a racket when that fight had begun.
It put all those sheep in a panicky run.
They all ran straight for a cliff and a terrible fate.
No way could I save them, for my help was too late.

Oh, what I would give for a well-trained dog to heip
me out on this day.
When Old Grudge came runnin' along the edge of the
cliff and turned them safely away.

Old Grudge risked his life on the cliff so steep
when the death of the sheep loomed so near.
The truth of it is Grudge ne'er saw one sheep.
He was just chasing a deer.

By now the sheep were headed straight for the barn
and Old Grudge was nowhere in sight.
I followed behind and saw up ahead
he was chasin' some quail up in flight.

He went down the trail, this way and that,
chasin' rabbits and wringin' his tail.
His back and forth antics was all that it took
to keep those old sheep on the trail.

Across the wide creek the barn was in sight,
but the sheep wouldn' cross it what ever I tried.
Frustrated and tired, I sat down by the water.
Whatever I tried, it just wouldn't matter.

I gave a big sigh and closed my eyes
when Grudge jumped in with a hurdle.
The sheep bolted in fear and crossed that wide creek,
but Old Grudge was just after a turtle.

The barn was now near, but the gate was not wide.
The sheep were all runnin', but to the wrong side.
I knew they were gone on past to the fields and wide
open grounds.
So, I screamed to Old Grudge "Way round you old
hound!"

He perked up his ear and took off a runnin'.
He knew I was mad and I sure wasn't funnin'.
Grudge ran like a bullet around to the right.
I didn't think he could make it, but maybe he might.

I couldn't believe he was after the sheep
when he went over the barn with a roof tall and steep.
He slid down the roof on the opposite side
and boy, he was pickin' up speed.

He was enjoyin' his ride on that wonderful slide
until he landed in front of the sheep.
He hit the ground runnin' and went way 'round the
herd,
and turned all them critters in one beautiful sweep.

Exhausted and tired, the sheep all ran in
and Old Grudge sat down in the gate.
He was lickin' his toe that he'd cut on the roof
and was makin' the sheep stop and wait.

I guess that one ear had heard every word
I couldn't believe what Old Grudge had done.
He knew what to do when he really had to;
he just wanted to still have his fun.

Not much to look at with just one ear and half blind,
His breedlng's not clear, you can easily see.
He's a critter of question, a one-of-a-kind,
but that's good enough for me.

When things got serious, he did his job
And, gave me all that he had.
He did his job well which showed me, at last ,
Old Grudge wasn't really all bad.

He was a puppy at heart and loved to play,
and I learned to never get mad.
I still have him today and he works in <u>HIS</u> way.
He's the best darned sheepdog that I ever had.

by Mary Hood